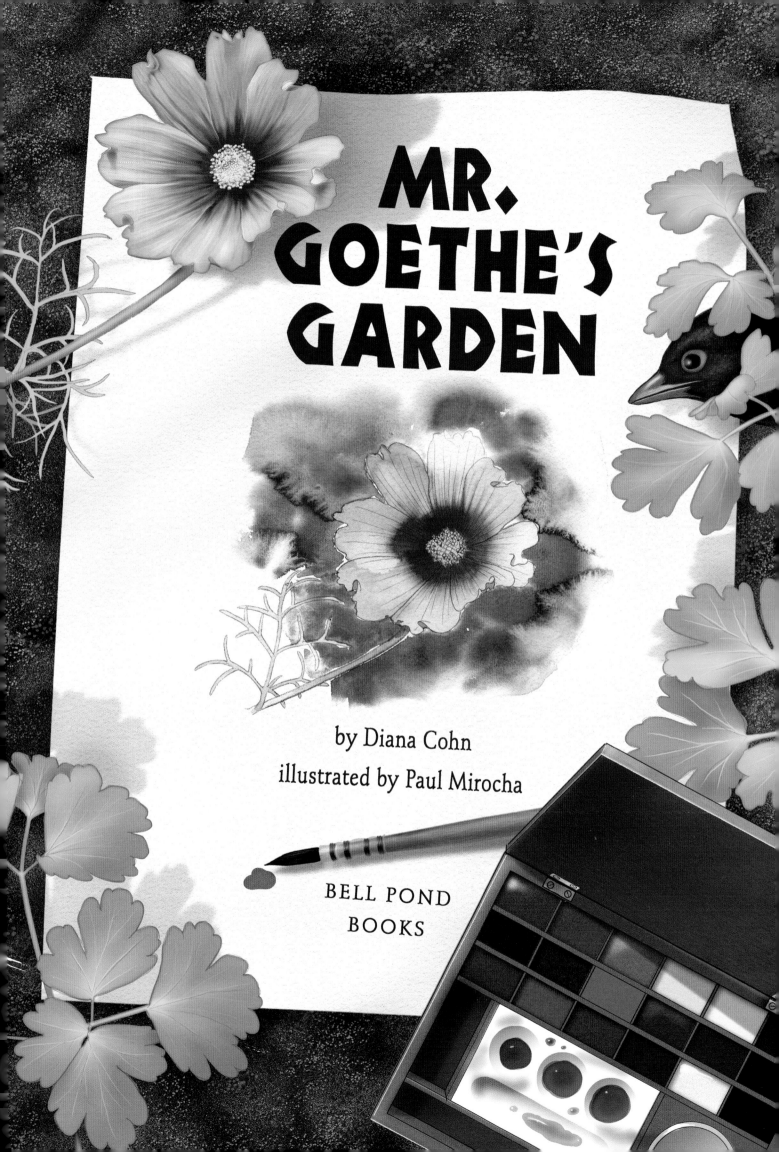

MR. GOETHE'S GARDEN

by Diana Cohn

illustrated by Paul Mirocha

BELL POND
BOOKS

*To know someone here and there who thinks and feels with us
and, though distant, is close to us in spirit — this makes
the earth for us an inhabited garden.*

- GOETHE -

A NOTE TO THE READER

The following is a fictional story about a young girl named Anna
and her friendship with a famous man who lived a long time ago,
whose name sounds very different from the way it is spelled. When
you read his name, it is read as "GUR-TA."

TEXT © 2003 BY DIANA COHN

ILLUSTRATIONS © 2003 BY PAUL MIROCHA

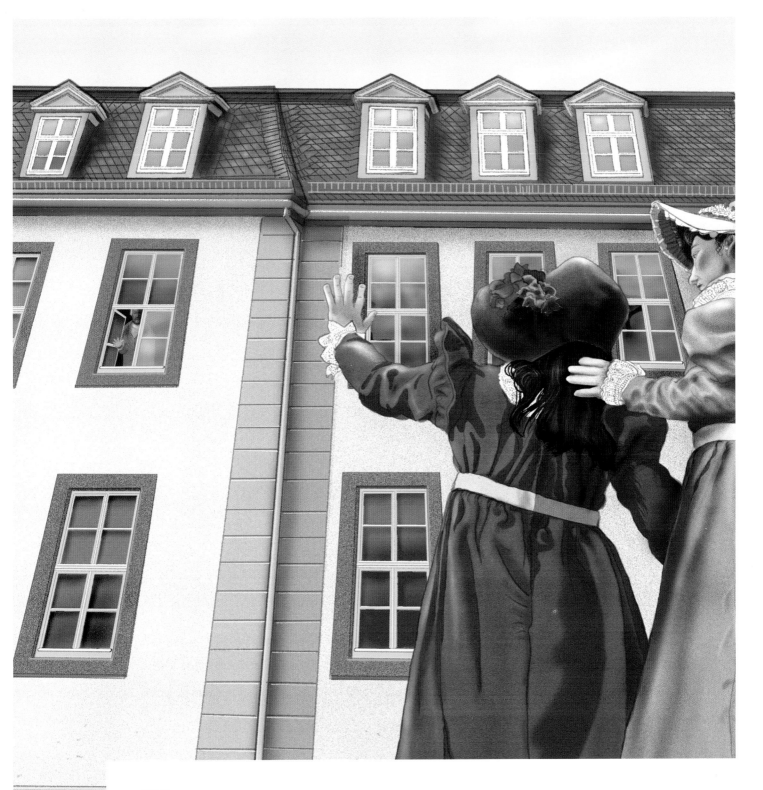

E VERY DAY I SAW HIM. His face was wrinkled from forehead to chin and he had silvery hair. On my way to my lessons, I waved and shouted, "Good morning, Mr. Goethe! Is it true the whole world is waiting for you to finish your play?"

"Please, Anna," my mother would whisper, "you must leave Mr. Goethe alone!"

But from his window, Mr. Goethe always waved back. "And a good morning to you, too, Anna!" he said.

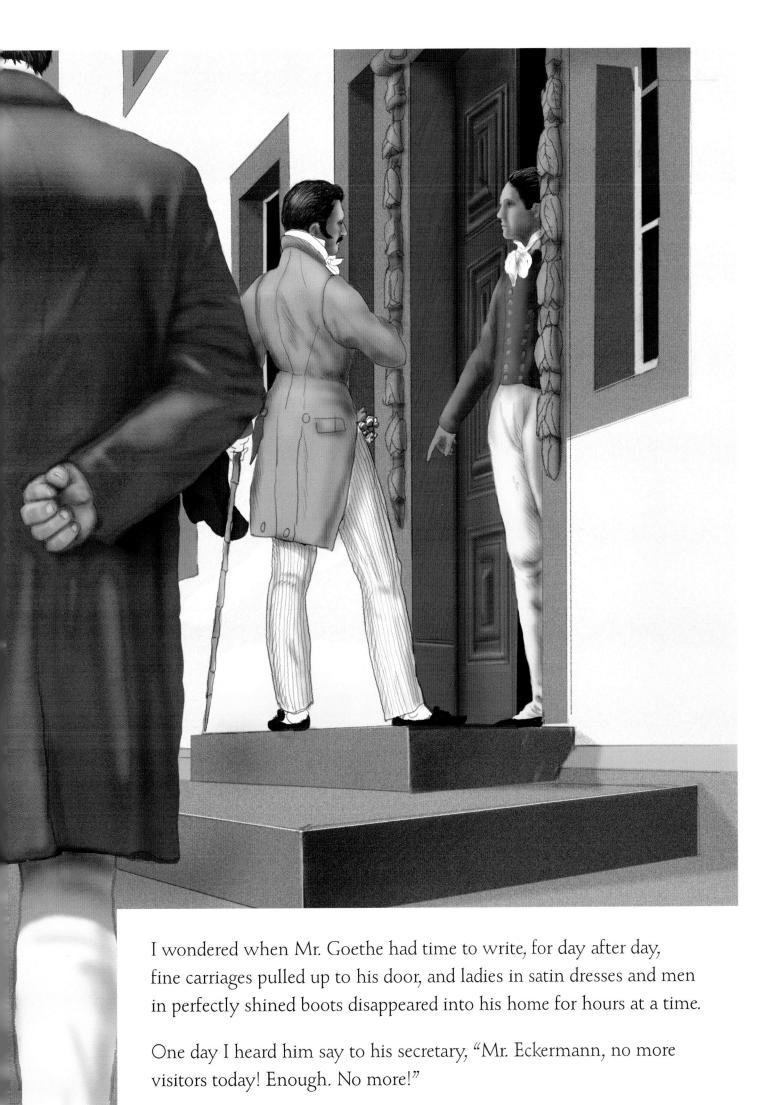

I wondered when Mr. Goethe had time to write, for day after day, fine carriages pulled up to his door, and ladies in satin dresses and men in perfectly shined boots disappeared into his home for hours at a time.

One day I heard him say to his secretary, "Mr. Eckermann, no more visitors today! Enough. No more!"

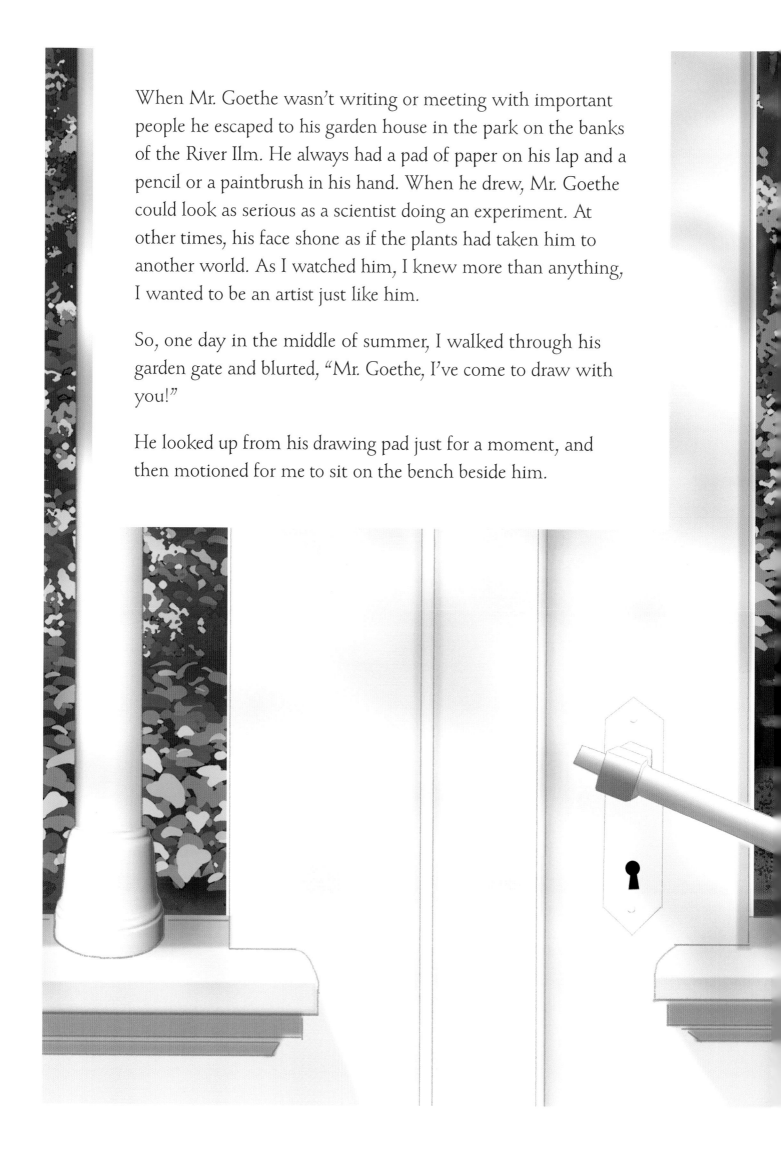

When Mr. Goethe wasn't writing or meeting with important people he escaped to his garden house in the park on the banks of the River Ilm. He always had a pad of paper on his lap and a pencil or a paintbrush in his hand. When he drew, Mr. Goethe could look as serious as a scientist doing an experiment. At other times, his face shone as if the plants had taken him to another world. As I watched him, I knew more than anything, I wanted to be an artist just like him.

So, one day in the middle of summer, I walked through his garden gate and blurted, "Mr. Goethe, I've come to draw with you!"

He looked up from his drawing pad just for a moment, and then motioned for me to sit on the bench beside him.

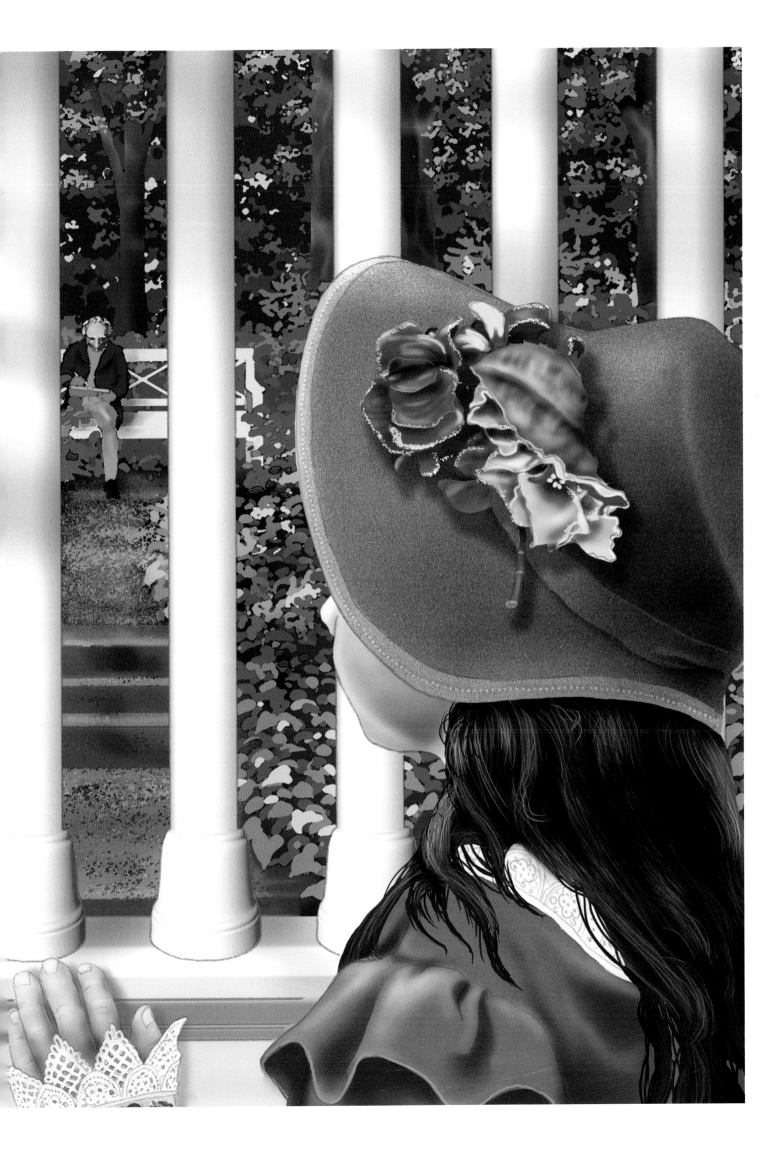

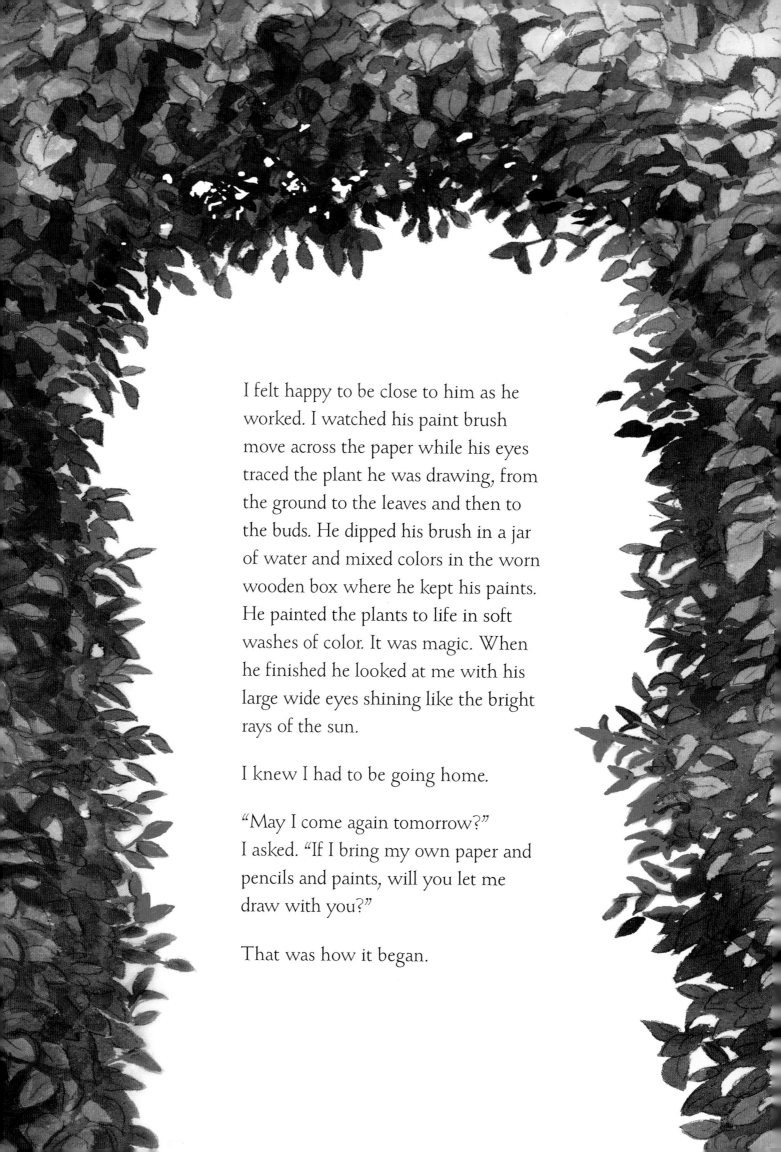

I felt happy to be close to him as he
worked. I watched his paint brush
move across the paper while his eyes
traced the plant he was drawing, from
the ground to the leaves and then to
the buds. He dipped his brush in a jar
of water and mixed colors in the worn
wooden box where he kept his paints.
He painted the plants to life in soft
washes of color. It was magic. When
he finished he looked at me with his
large wide eyes shining like the bright
rays of the sun.

I knew I had to be going home.

"May I come again tomorrow?"
I asked. "If I bring my own paper and
pencils and paints, will you let me
draw with you?"

That was how it began.

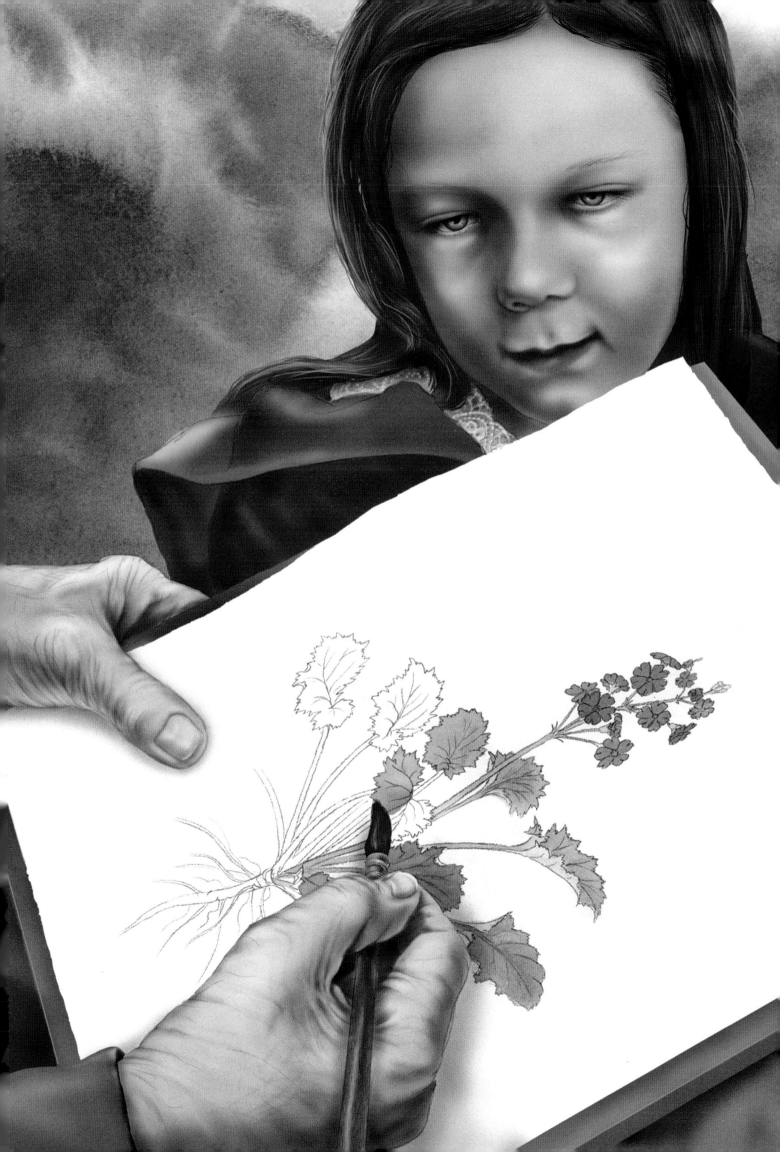

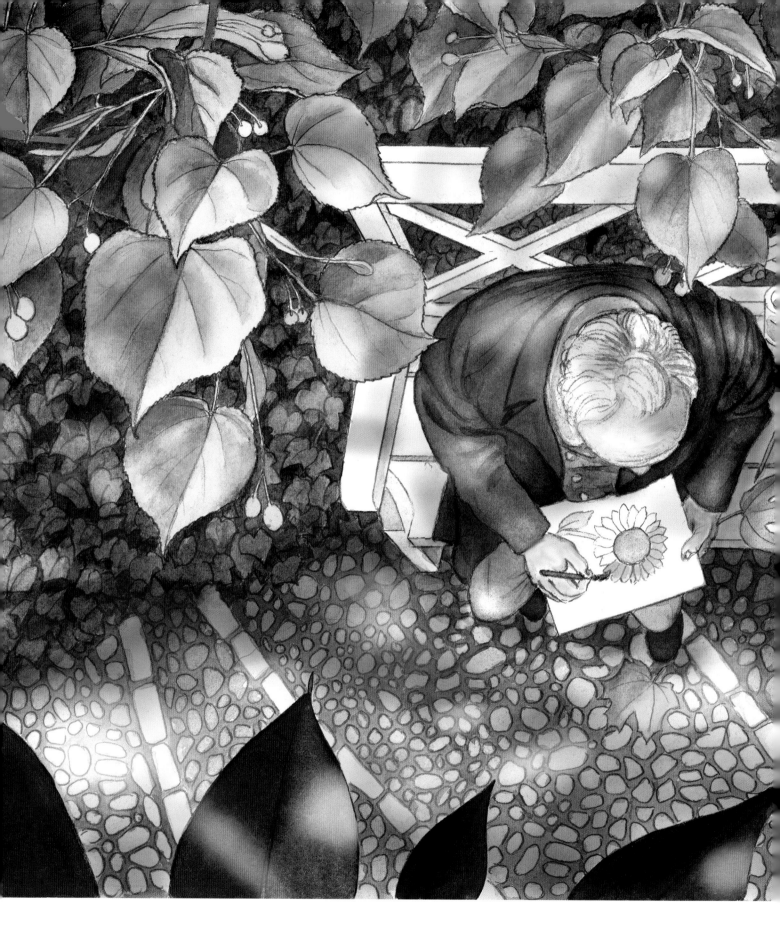

We met almost every afternoon. We collected leaves of all shapes and sizes. We painted sunflowers and mallow and grapes and strawberries. And with the finest pencil, I drew the soft, wispy leaves of the asparagus and the thin, delicate petals of the cosmos.

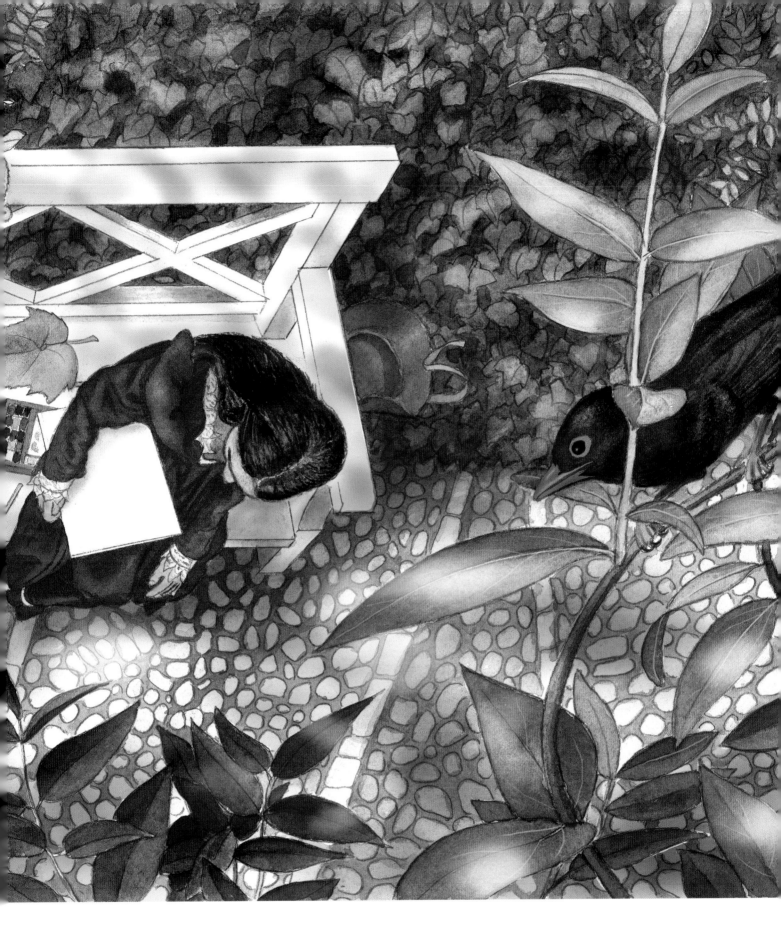

As Mr. Goethe painted the garden to life, I couldn't help thinking how beautiful his paintings were. I put down my drawing pad and asked, "Mr. Goethe, how did you ever learn to paint these plants so they look so alive?"

Mr. Goethe turned his kind face to me. "First," he said, "I listen with my eyes. I give each plant my full attention, as I do you. Like friends, plants tell you their secrets only when they know you care."

I did not understand what he meant, but Mr. Goethe often said strange things, so I repeated his words silently to myself.

"Don't worry," he said, as he picked up my drawing pad and handed it back to me. "Just practice listening with your eyes, and one day when you least expect it, you will see with your heart and be swept up into nature's dance."

"Nature's dance?" I asked, wondering again what he meant.

"Oh, yes," Mr. Goethe said, "nature never stands still, not for a single moment! She's always changing and moving in a rhythm all her own."

I continued to draw day after day after day. I tried listening with my eyes and seeing with my heart in the special way Mr. Goethe had told me. I studied the trumpet-like blossoms of the lily and listened carefully. I sketched the soft red petals of the poppy and let my heart guide my hand.

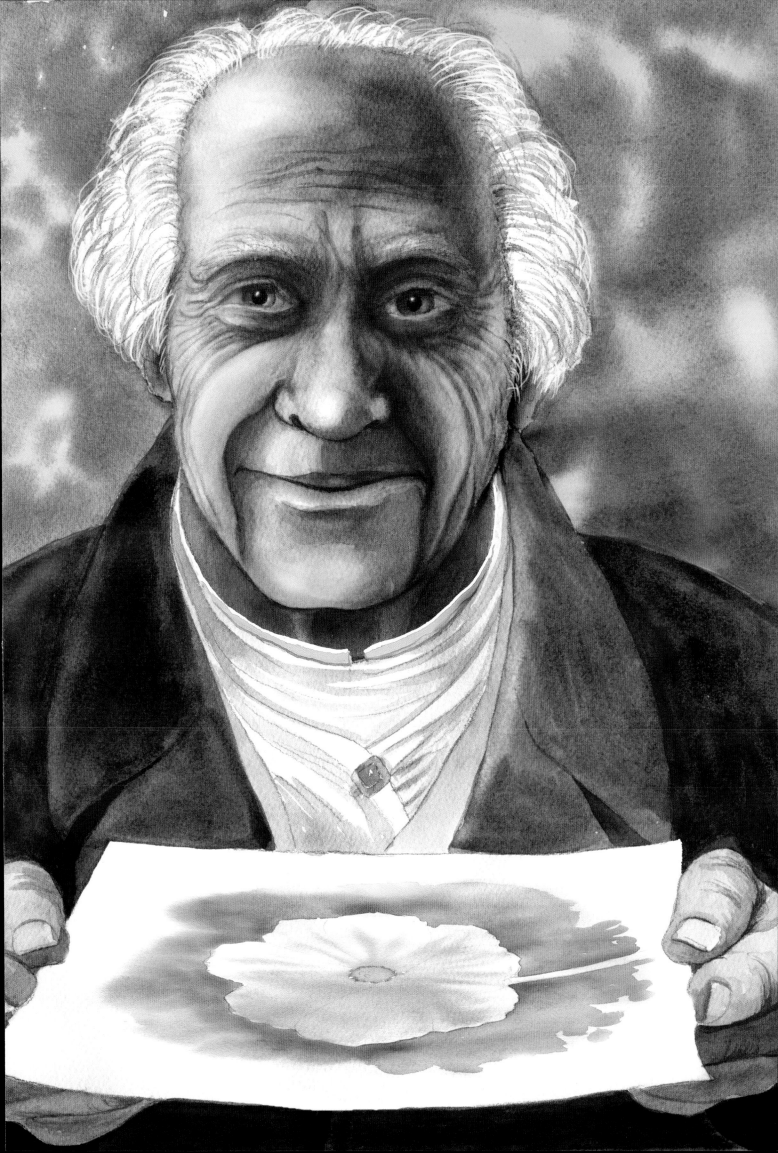

One day I painted roses that looked like pink and red stars
bursting in a universe of green leaves. First I dipped my brush
in crimson-red pigment and painted the little roses
that were on the bush in front of me. Then I painted
a soft transparent wash of pink for all the roses
that were in bloom.

I didn't notice that Mr. Goethe was watching
me paint until he said, "The rosebud is
nature breathing in, just like the dots
in your painting."

Then he gently took my hand and closed
his hand over it. "It's like your fingers making
a fist, tight and hard."

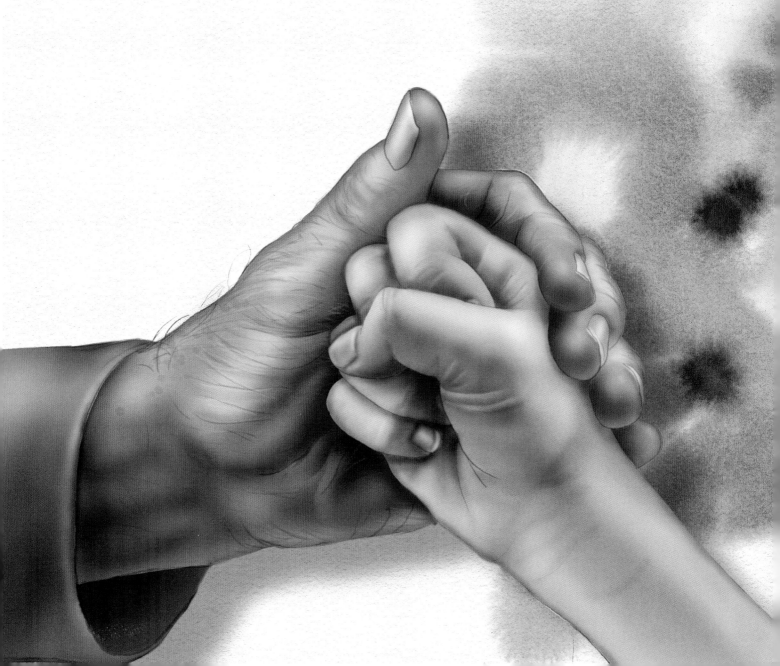

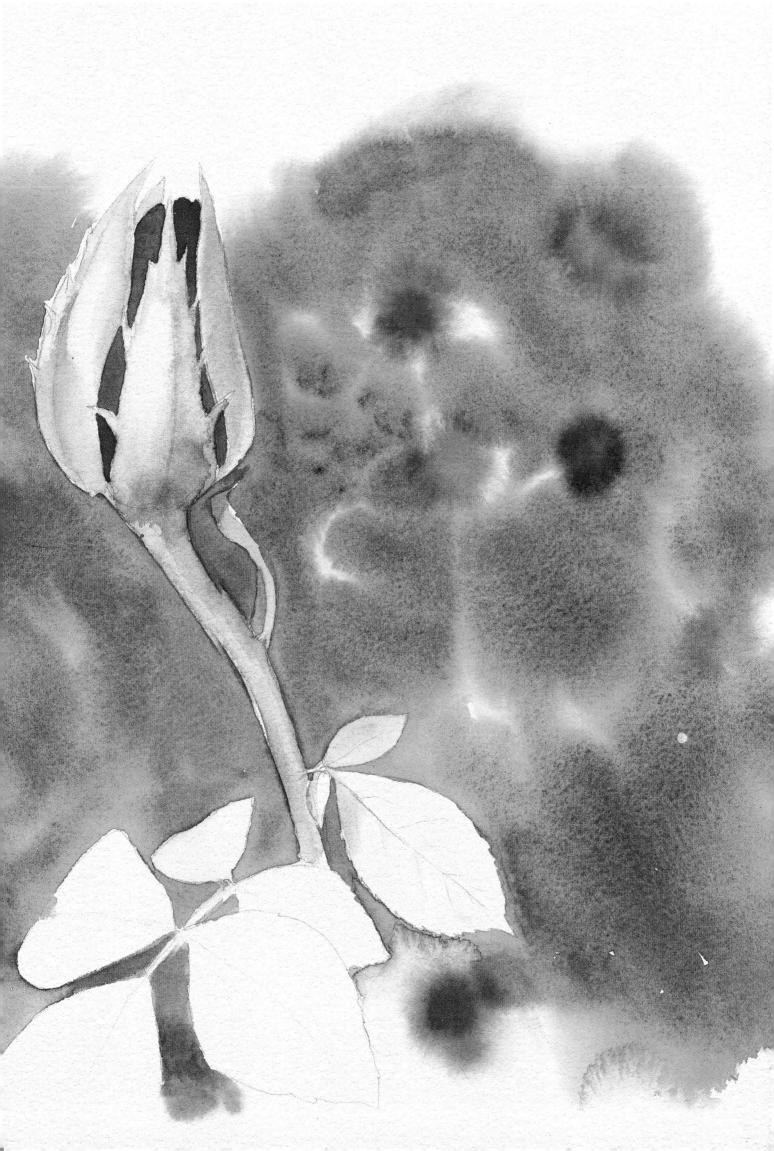

"And the blossom," he said, "is like your hand with your fingers stretched wide into space." Mr. Goethe then opened my hand and stretched it against his.

"Mr. Goethe," I said as I took my hand and made it into a fist again, "the bud is like a wrapped present."

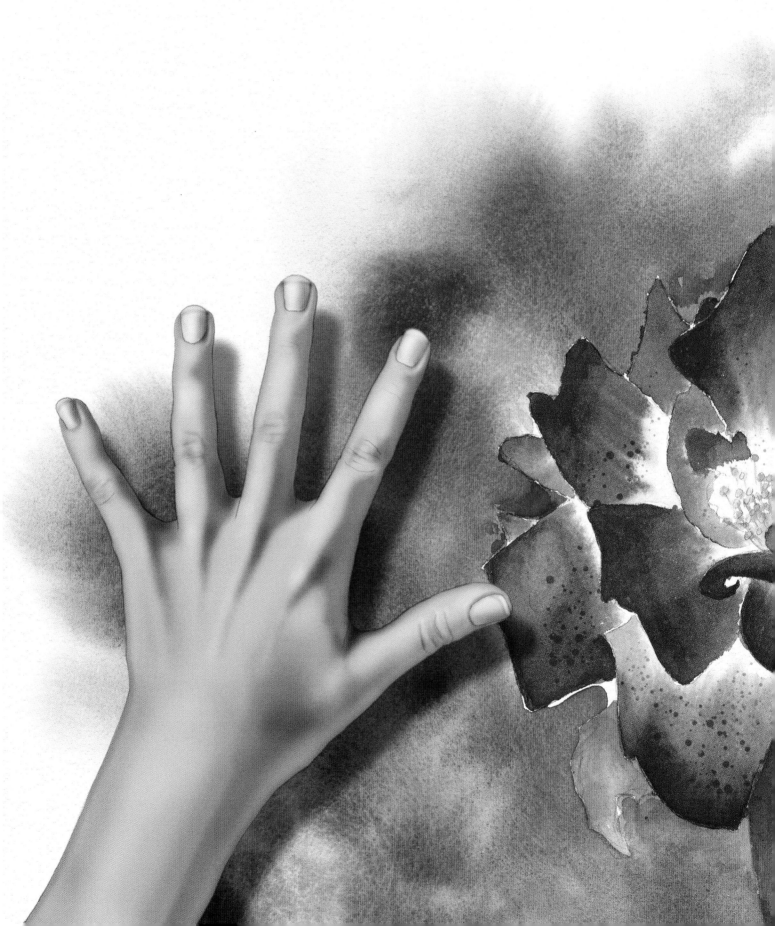

I thought about getting a gift all wrapped up, and not knowing what was inside. I stood up and twirled and stretched my arms wide. "The blossom is the gift, the surprise! It is the plant breathing out color," I said.

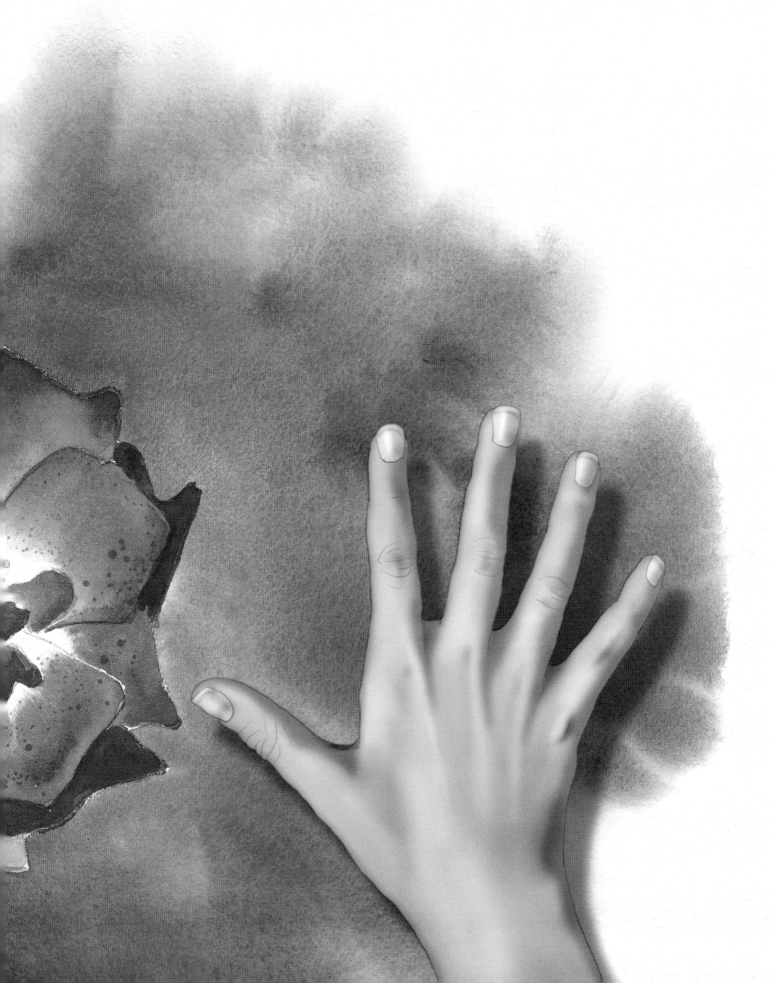

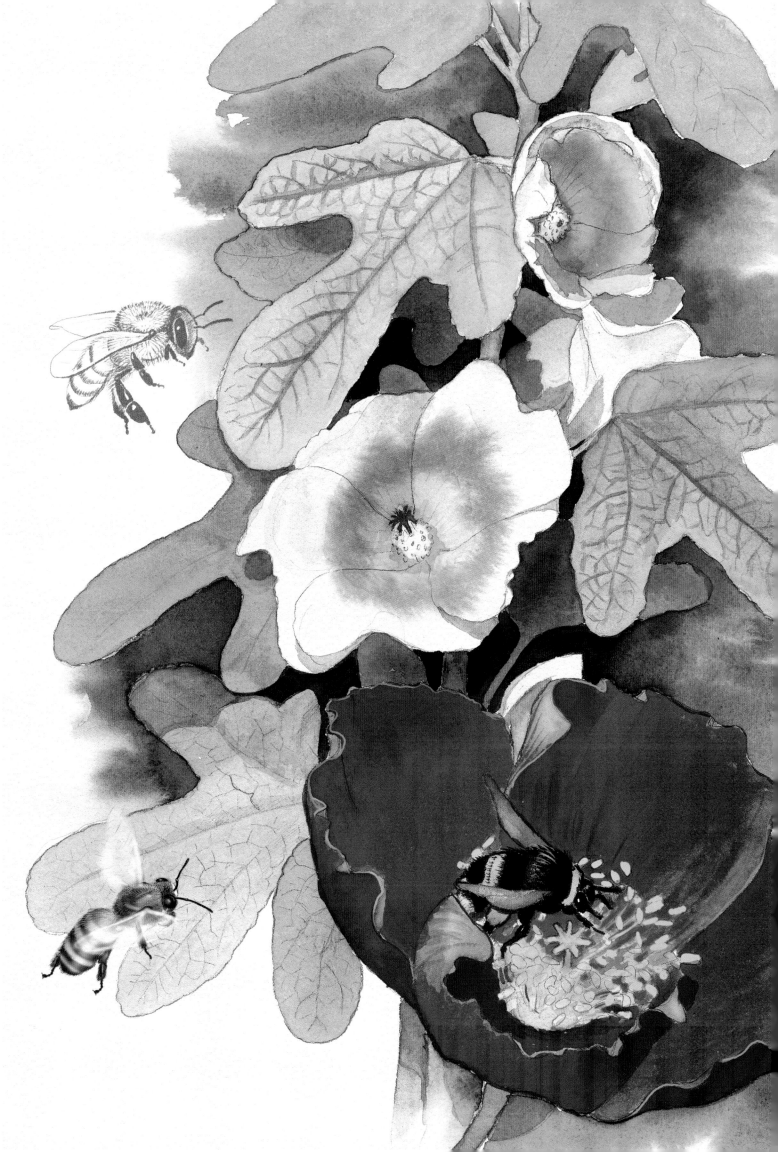

When I saw the roses and hollyhocks and poppies and all the other garden flowers, I realized the air was filled with the hum of bees. Everywhere they were busily feasting on nectar and collecting pollen.

"Mr. Goethe, look!" I said. And we stopped and listened.

Mr. Goethe's voice blended with all the humming, and he whispered, "After the bees and butterflies and even the wind have done their work with the flowers, the plant draws itself in."

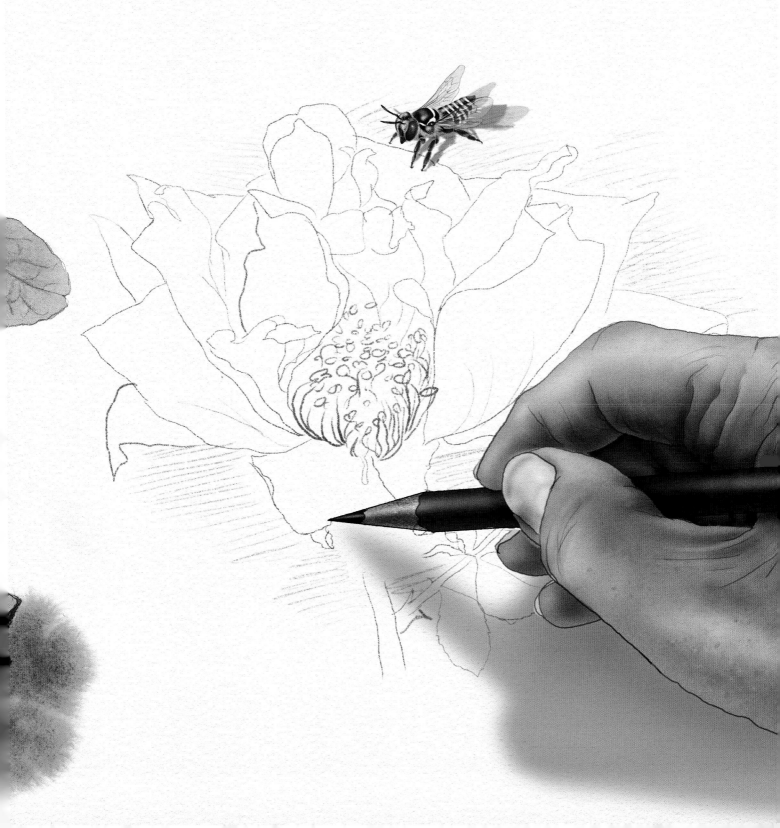

"Into the seeds!" I said.

"Yes, and when the seeds find their new home in the soil, the whole cycle begins all over again," he said.

We continued to paint all through the summer and fall. We painted rusty brown pears and red and yellow apples. We painted the swollen red rose-hips that protected the seeds nestled safely inside.

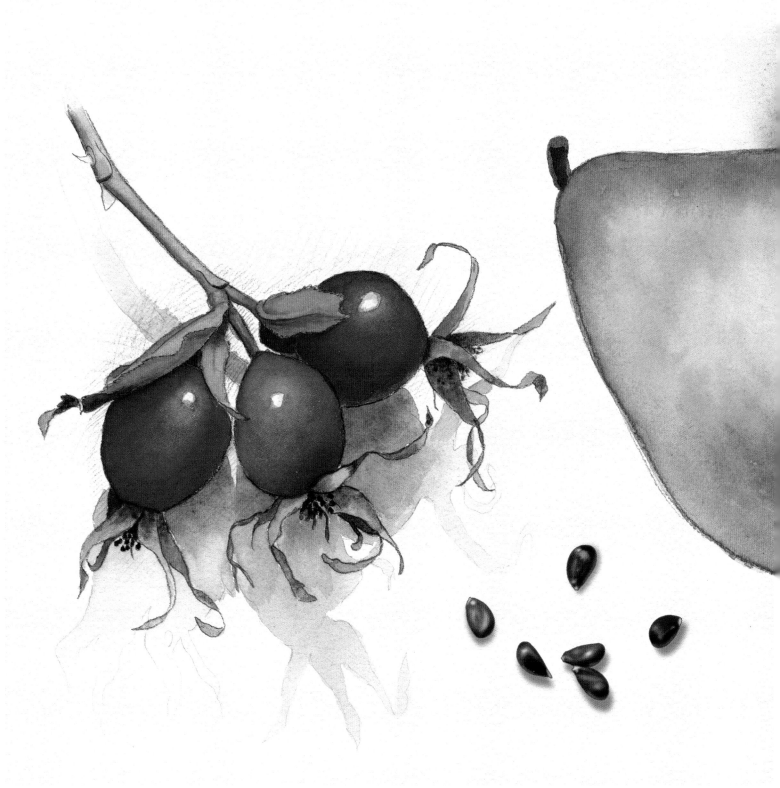

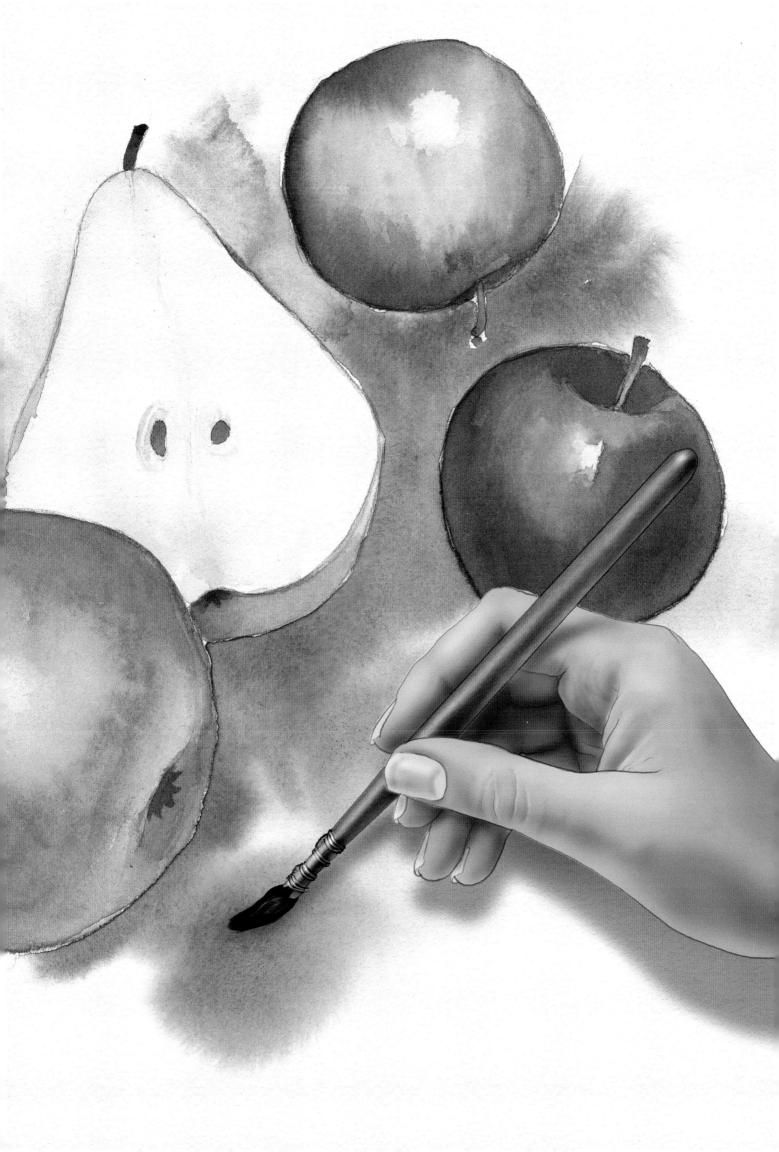

When the brisk autumn air began to bite and the wind stirred
with the color of falling leaves, the garden plants began to wither
and die. It became too cold to draw, so we pulled out the dead plants,
collected seeds, and made the garden as neat as we could.

"My dear," Mr. Goethe said, "the garden has been dancing so hard
she needs the wintertime to rest. But before you know it spring
will be here. And now, I must go and finish my play
once and for all."

While Mr. Goethe wrote, our garden rested beneath a blanket of snow.
Every morning I waved and shouted, "Good morning, Mr. Goethe!"
and waited for him to look out of his window and call out,
"And a good day to you, too, Anna!"

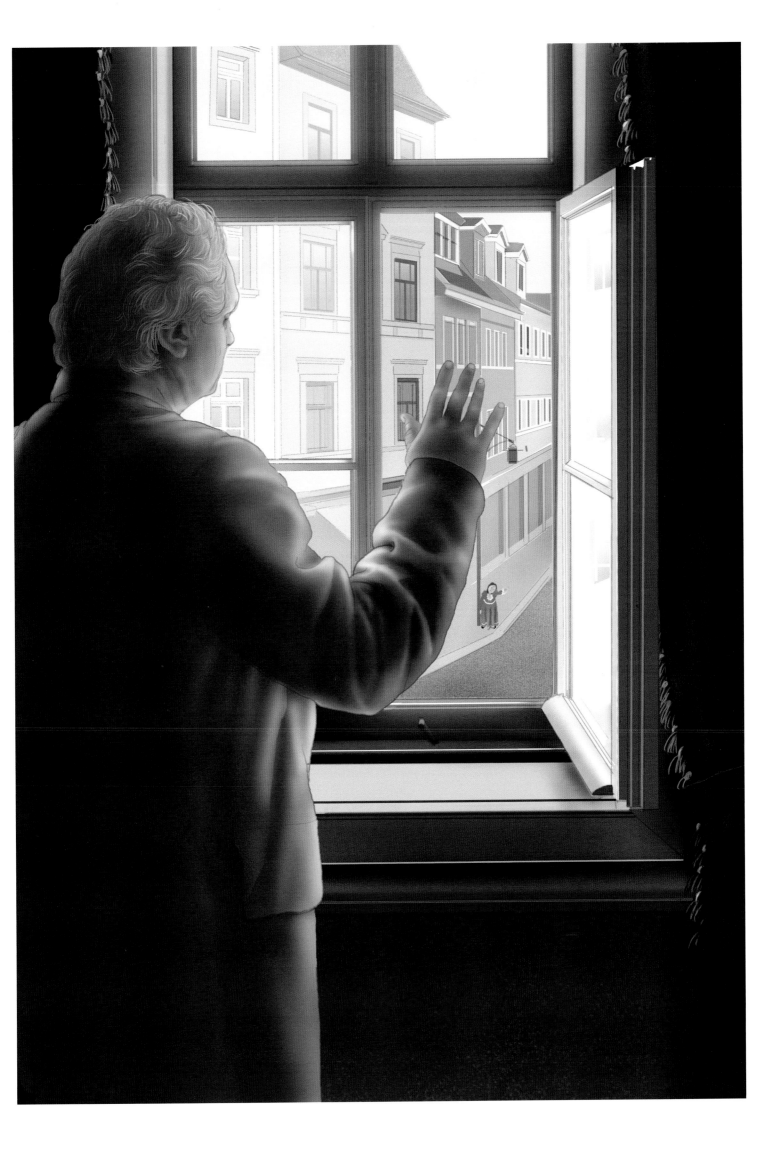

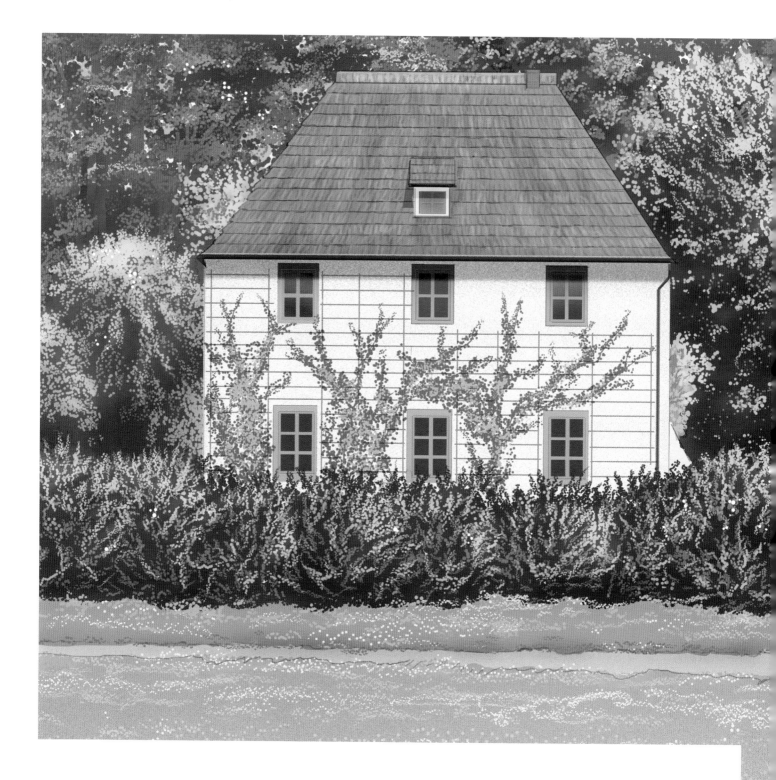

After the long winter, the air began to smell of mud, and I was ready to go back to the garden with my neighbor. But we could not do so. For right after Mr. Goethe finished writing the very last lines of his play, he died peacefully in the armchair by his bed.

When my mother told me, I cried. "It's not true!"

Each day I believed I would see him by his window where he used to wave to me on my way to my lessons. The first weeks after he died passed slowly, and I didn't think I would ever want to draw again without him. But one afternoon, I gathered my pencils and my brushes and paper and decided to revisit his garden.

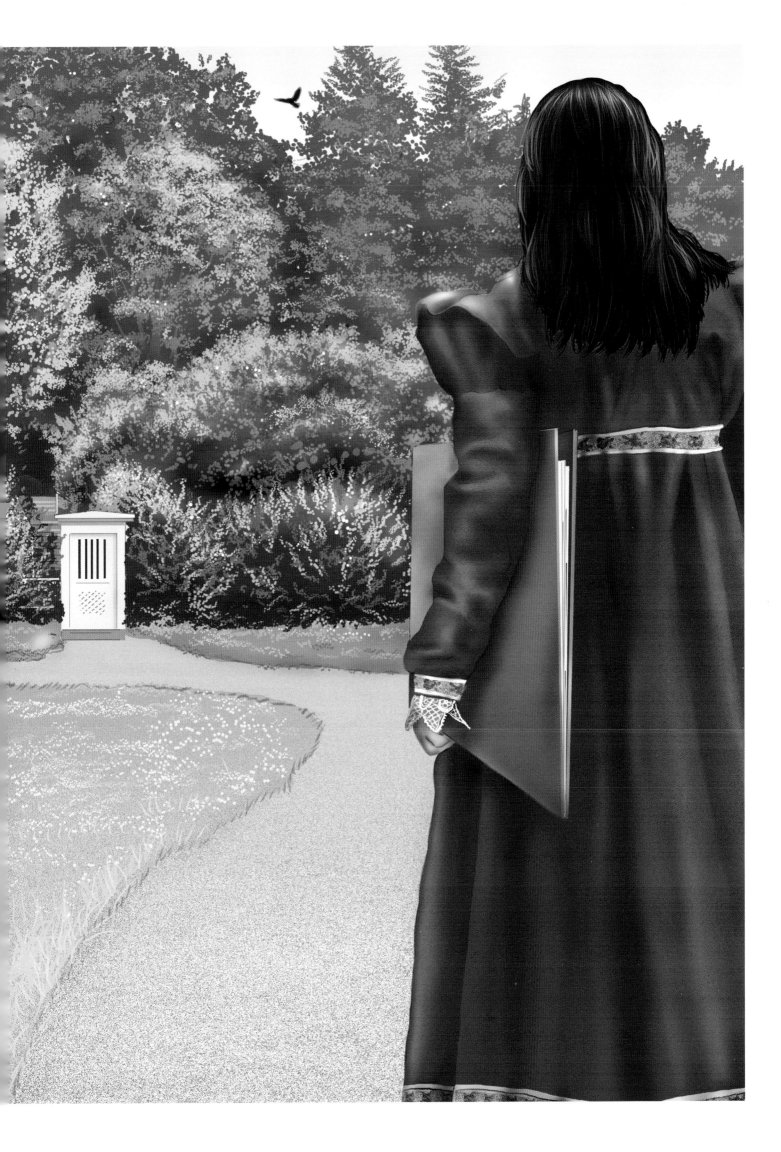

As I pushed open the garden gate, I could see the bench where we used to sit together. The sun filled my eyes. I began to look around as the sun showed me one plant after another — tulips, violets, irises, and bluebells — plants I remembered now, each by name.

With their names came his words, "Plants, like friends, tell you their secrets only when they know you care."

I chose one flower and, as I drew, I listened with my eyes. I thought of all these plants, my friends, surrounding me, and again I heard his voice in my mind as if he were sitting right next to me, saying, "One day when you least expect it, you will be swept up into nature's dance!"

When I looked down at my painting, the most beautiful image was there. Now I couldn't stop. I found leaves and insects and buds and colors, and then like a seed finding its way toward the light, my heart was afire.

Like a great kaleidoscope, my imagination began to turn. Round and round, leaves, buds, blossoms, fruits and seeds moved . . . expanding and contracting, breathing in and out and in and out.

My heart was seeing and my eyes were listening as the garden plants sang and called out, "Anna, Anna! Look at me! Look at me!"

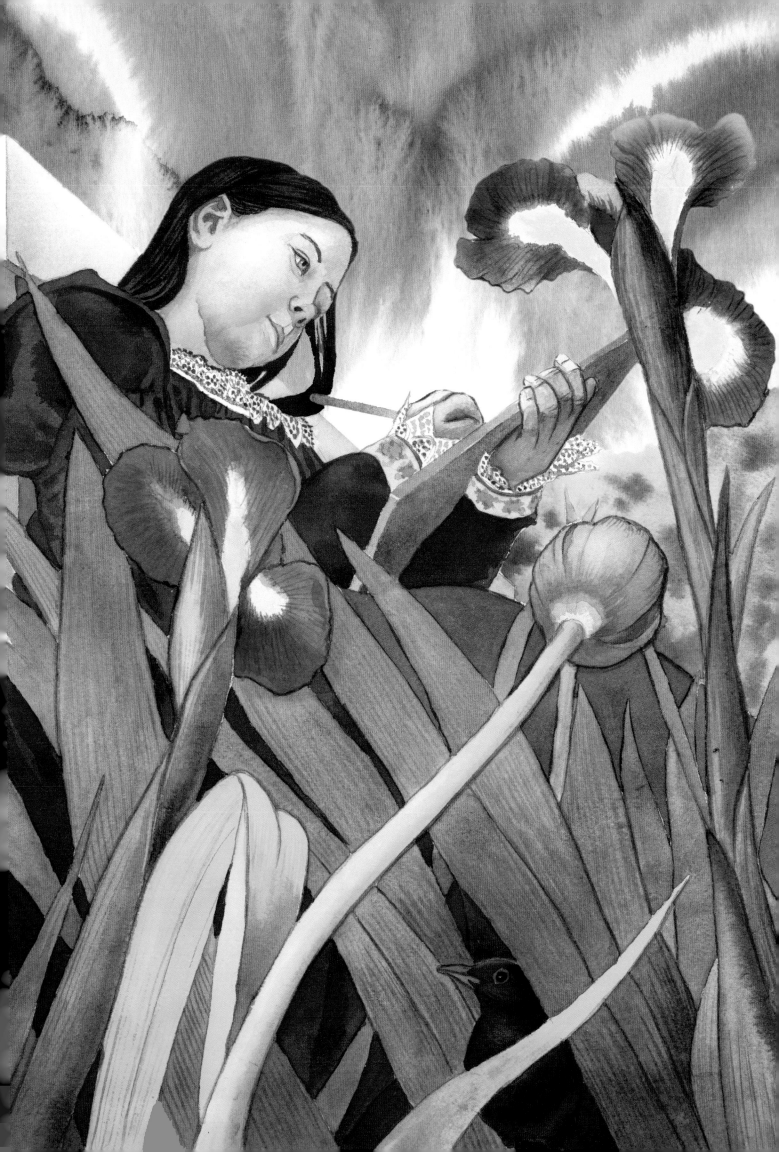

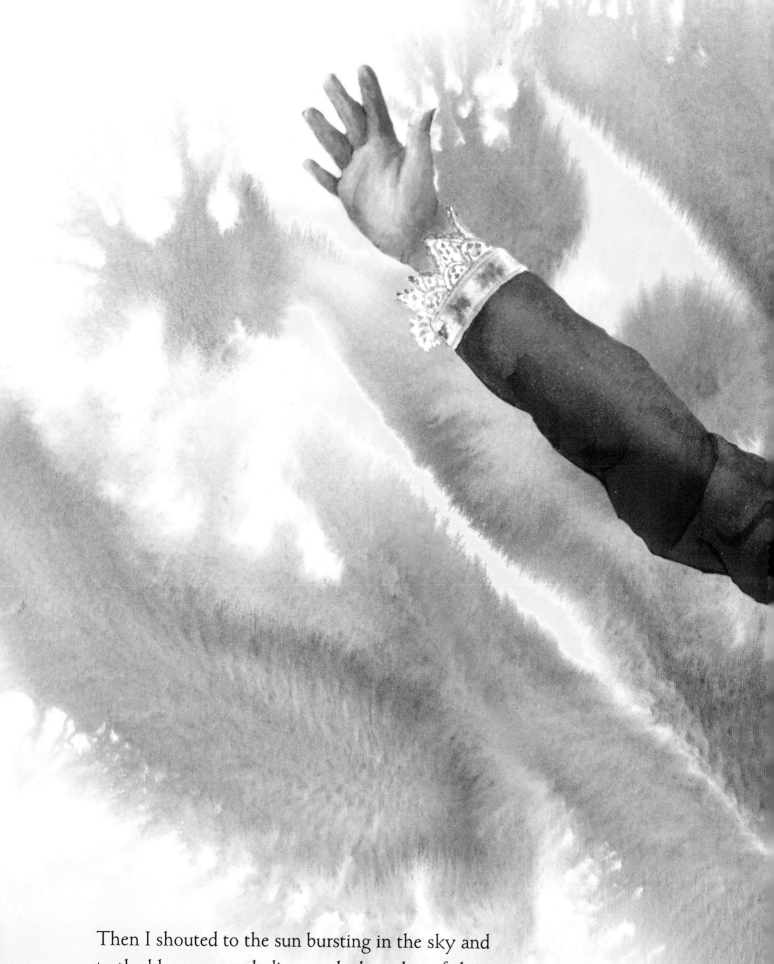

Then I shouted to the sun bursting in the sky and
to the blossoms exploding on the branches of the trees,
"Mr. Goethe, I am dancing with her!"

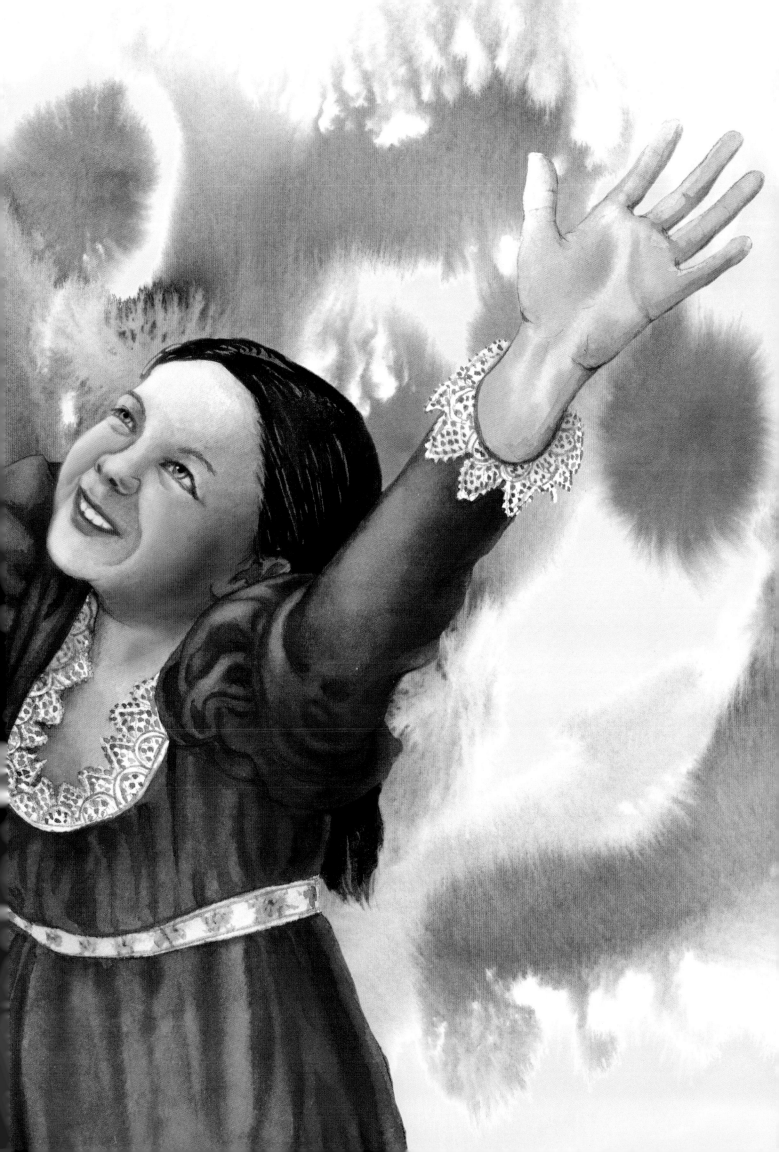

A GLANCE AT MR. GOETHE'S LIFE

Who Was Mr. Goethe? What Did Mr. Goethe Do?

The Early Years.

Johann Wolfgang von Goethe was born on August 28, 1749, in Frankfurt, Germany. From earliest childhood, he loved words and drama — and nature. Deeply imaginative, he loved to tell stories, create his own puppet shows, and create altars of objects he found in nature. By the age of eight, he knew some Latin, Greek, French, and Italian.

At sixteen, Goethe left home to study law. He also studied drawing. Eight years later, while practicing law, he wrote a novella, *The Sorrows of Young Werther*, that brought him international fame. He became a best-selling author — one of the first! At twenty-six, he moved to Weimar, the city that would become his home for the rest of his life. In Weimar, Goethe held political office and had many important responsibilities.

The Garden House.

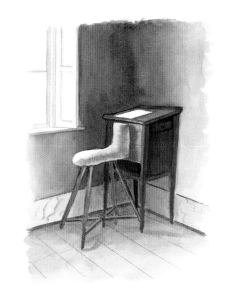

In 1776, Goethe moved into a little garden house given to him as a gift from Carl August, the Duke of Weimar. He lived there for six years. The furnishings were simple and sparse. Although he was a statesman involved in the daily life of the city, Goethe's heart was in his writing and art and in his studies of nature. At the garden house he wrote in the early morning, standing at his high desk.

Goethe also devoted himself to his garden. It was a place of rest, as well as a laboratory for botanical experiments. Although Goethe later moved to a larger home to make room for his growing family and his many visitors, he visited the garden house often. He considered it to be his special place — a sanctuary — far away from the disruptions and distractions of the city.

The Italian Journey.

When Goethe was thirty-eight years old, he left Weimar for two years, traveling to Italy to study art, architecture, and plant life. He wanted to practice the "art of seeing" and test his powers of observation. He wrote, "I want to open my eyes, gaze humbly, and await the image which my soul will make for me . . . all roads are open to me, because I walk in a spirit of humility." With this attitude of reverence — "listening with his heart and seeing with his eyes," as *Mr. Goethe's Garden* puts it — he discovered something new while walking in the botanical gardens of Padua. Describing this experience several years later, Goethe wrote, "If we observe all forms, especially organic ones, we find that nothing is permanent, nothing is at rest or complete, but rather that everything is in continuous fluctuating movement." Within this fluctuating movement, however, Goethe also saw a "constant" — a unifying idea or oneness that is integral or common to all plants. Goethe spoke of this discovery as the most glorious moment of his life.

A New Kind of Science.

When Goethe returned from Italy he knew he had to devote the rest of his life to writing. In addition to plays and poetry, he also wrote scientific papers, including *The Metamorphosis of Plants*. In this paper, he describes three alternating cycles of expansion and contraction in flowering plants.

The *seed*, as the first contraction, is the most dense.
It unfolds to the *leaves*, the first expansion.
The second contraction is the *bud* or *calyx*.
The *blossoming flower* is the next expansion.
The formation of the *pistil and stamens* is the third contraction.
Lastly, comes the *fruit*, the final expansion . . . within which is the contracted *seed*.

To see these rhythmic movements, Goethe brought imagination and loving attention to his observation. He observed the qualities of the plant — the form and color and texture — and was especially interested in the transformations of the leaf from one form to another.

The Final Years.

Goethe spent his final years writing and conducting scientific studies. Over the years, he created a herbarium that included the leaves of over 2,000 plants, which he pressed, glued down, and labeled. He also had over 15,000 pieces in his mineral collection, including rocks and minerals from Germany as well as other regions in Europe. He collected over 5,000 books in his library, and his passionate interest in drawing led to filling 1,000 pieces of paper with sketches and drawings.

Goethe continued to write in the mornings, but — instead of standing at his high desk — he now paced back and forth across his studio floor, dictating to his beloved friend and secretary Johann Peter Eckermann. For the last eight years of his life Goethe wrote between 300 and 400 letters a year!

It took Goethe fifty-seven years to complete his most famous work, *Faust*, writing the last lines just before he died in 1832.

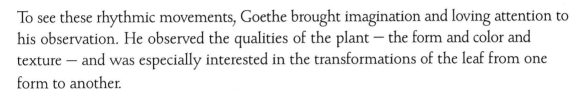

As a grandfather, Goethe loved young children. They were the only ones he allowed to enter his studio when he was working. For his granddaughter, he made beautiful flower garlands and put them in her hair.

Although Goethe is remembered for his literary works, he himself placed the highest value on his natural scientific work. One of his greatest hopes was that this work would not be overlooked. *Mr. Goethe's Garden* was written with the hope of bringing more attention to Goethe's botanical insights and to his unique approach to observing nature.

For Marjorie Spock, Charlie Hutchison, Plummie Razi, and Paul Hawken,
who have kept me company on the Goethean path. [D.C.]

Dedicated to my daughters, Anna and Claire Mirocha, who already
knew that plants are their friends. [P.M.]

A very special thanks to the many people in Weimar who helped us with this book, especially Angela Jahn and Barbel Rottorf from the Stiftung Weimarer Klassik who reviewed this manuscript, Petra Ellerman-Rinda and Inge Scholz from the Weimar-Klassik Fototek who welcomed us into the Goethe photo archives, Barbara Engelmann from the Stadtmuseum Weimar who helped us do valuable research on the costumes of the time, Anne Weinhold from the Weimar internet café, and Elfriede Passaro from the German National Tourist Office.

A bouquet of poppies and hollyhocks for Allegra Breedlove for modeling the character Anna in the story, Reneé Clouthier and Mary Ann Trombino from The Gaslight Theater costume shop, Nanalie Rapheal and Barbara Tanzillo from the costume design shop of the Arizona Theater Company, Irene Cherchuck, Rhod Lauffer, Donald Sayner, Steve Buchmann, Nikos Valance, Mitzi Cowell and the students of the Satori School, the fourth-graders at the Lyons school, Shellei Addison, Irene Grace Goldszer, Scott Treimel, Susan Patron, Nikki Estrada, Peggy Orr, Ann Gondor, Gene Gollogly, Christopher Bamford, and Mary Giddens *who helped this book evolve into its final form.*

A bouquet of tulips and bluebells for Susan Cohn-Schulz, Jennifer Beckman, Kewulay Kamara, Gunther Hauk, Craig Merrilees, Sara Wendt, Amy Goodman, Ellen Coon, Amy Cordova, Barnet Schecter, Janet Lansberry, the South 40 Pier garden committee, Susan Sully, Stephen McCormick, Barbara and Bert Cohn, Anjana, Purna, Prajwol and Siddhartha Shakya, Margeret Pennock, Dylan Kenney, Robert Phipps, Colin Cochran, Paul Langland, Magnus Isacsson, Anannya Bhattacharjee, S. Shankar, Ujjayan Siddharth, Annie and Howie Cohn, Amy and Henry Liss, Grove Burnett, Norman Solomon, Steve Smith, Peter Teague, Lisa Cooper, Heidi Johnson, Bridget Keating, Anuradha Mittal, Gary Nabhan, Lynn Gray, Victor A. Bloomfield, Chester Mirocha, Donna Mirocha, Nancy Moran, Kay Sather, Mary Woltz, Andrew Bachmann, Barbara Skye, Sharon Ebert, Linda Rossi, Elizabeth Compton, Barbara Kingsolver, Ann Bastian, Emilie Buchwald, Gretchen K. Halpert, Waldemar and Sophie Kulczycki, Nora Mirocha, Colin Greer, Steve Buchanan, Jan Kunz, Stephanie Ellison, Shelly Gillum, Molly Luna Iris, and the spirit of Mr. Goethe *who make this life for us an inhabited garden.*

Published by Bell Pond Books
P.O.B. 799, Great Barrington, MA 01230

www.bellpondbooks.com

LIBRARY OF CONGRESS CATALOGING-IN-PUBLICATION DATA

Cohn, Diana.
Mr. Goethe's garden / by Diana Cohn ; illustrated by Paul Mirocha. -- 1st ed.
p. cm.
Summary: In the 1830s, a young girl visits her neighbor, the famous author, artist, and naturalist,
Johann Wolfgang von Goethe, and they talk and paint together in his garden.
Includes a biographical summary of Goethe.
ISBN 0-88010-521-6
1. Goethe, Johann Wolfgang von, 1749-1832--Juvenile fiction. 2. Goethe, Johann Wolfgang von, 1749-1832.
[1. Goethe, Johann Wolfgang von, 1749-1832--Fiction. 2. Gardens--Fiction. 3. Painting--Fiction.
4. Goethe, Johann Wolfgang von, 1749-1832. 5. Authors, German. 6. Naturalists.]
I. Title: Mister Goethe's garden. II. Mirocha, Paul, ill. III. Title.
PZ7.C6649Mr 2003
[E]--dc22
2003017767

The text is set in Schneidler Mediaeval. The illustrations were done as digital paintings, and using traditional watercolors.

10 9 8 7 6 5 4 3 2 1

Manufactured in Hong Kong